D1645193

BADLY REPAIRED CARS
RONNI CAMPANA

HOXTON MINI PRESS

Badly Repaired Cars
First Edition

Copyright © Hoxton Mini Press, 2016.
All rights reserved.

All photographs © Ronni Campana

Introduction by Tom Seymour

Design and layout by Studio Thomas

Series conceived and developed
by Hoxton Mini Press

Printed and bound by
C&C Offset Printing Co., China

ISBN 978-1-910566-08-4

A CIP catalogue record for this book
is available from the British Library

First published in the United Kingdom in 2016
by Hoxton Mini Press

To order books, collector's editions
and signed prints please go to:
hoxtonminipress.com

Book 1:
Bubblegum

Book 2:
Badly Repaired Cars

Book 3:
Hand Jobs:
Life as a Hand Model

Introduction

The unforeseen circumstance. The thing that goes wrong. The unpredictable disaster. It doesn't matter if you're the most successful person in the world, or a bit of a mess. It doesn't matter if you drive a Rolls Royce or your great aunt's clapped-out banger. We can all still back into a covert wall, become at one with an unseen bush.

A bent aerial, a hanging wing-mirror, a smashed window; however hard we try, these events remain maddeningly out of our control. And yet there's always places to go, things to do, a life to be lived. We must keep calm, do what we can, and carry on.

Over the course of a year, Ronni Campana, the London-based photographer and a native of Milan, would carry his Canon and remote trigger Speedlite on his commute to work. Walking across East London, he would search for badly fixed cars.

Once he found an appealingly shambolic repair, Campana would hover there, often until he was moved on, detailing the quick fix with close, tightly-cropped frames, inviting us to see beyond a knackered old car; to look at geometric shapes, pastel colours and smooth, curving lines.

By doing so, Campana asks us to celebrate the mechanics *and* the bodge-job. The craftsmanship *and* the temporary repair. The underlying engineering *and*

the 'Fuck this, it'll do. Now hop in and let's get going.'

Here, a second-hand '99 Ford Ka – like the one Ronni drives – or a Fiat Punto in a Bethnal Green garage, can assume the grace of a Mondrian painting, or a great gleaming structure seen from high above

It's an ode to resourcefulness and ingenuity, to emergency cardboard, plastic bags and duct tape. A recognition that stuff does goes wrong, and yet we carry on.

And so maybe these simple photographs could be metaphors; for us, for life. Of how, a little broken, older all the time, rougher around the edges than we might like to be, we still find a way of getting on. And, often, we do a pretty good job of it.

Tom Seymour, London, 2016.

Ronni Campana

Born in Milan in 1987, photographer Ronni Campana specialises in photographing the world's minute imperfections. By concentrating on details in his surrounding environment and framing contrasting colour and shapes he uncovers an abstract beauty in seemingly mundane objects. With the use of subtle humour and a bright flash he draws our attention to the wonderful flaws found in everyday life. *Badly Repaired Cars* is his first book.

Hoxton Mini Press

Hoxton Mini Press is the smallest imaginable publisher based in East London and is run by Martin, a fine art photographer and Ann, who has worked in galleries for many years. They are dedicated to making photography books more accessible (and playful) and think that as the whole world goes online beautiful books should be cherished. Feel free to stroke, lick or eat this copy. They also have two dogs, Moose and Bug, who don't give a crap about art. *hoxtonminipress.com*

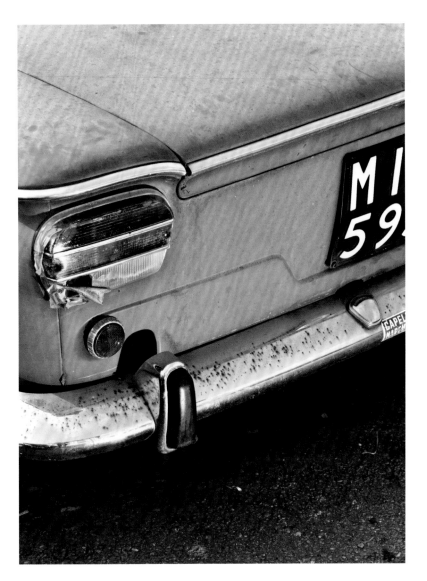

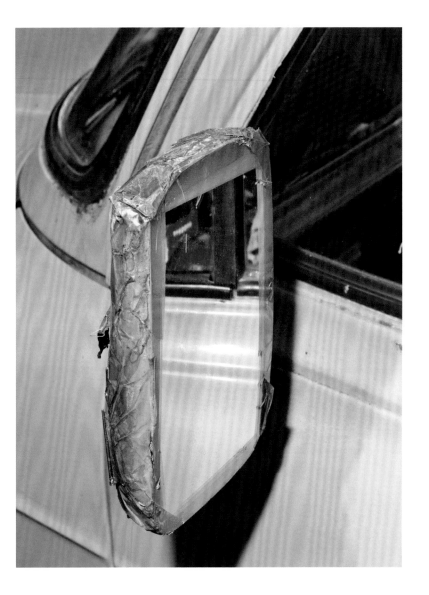

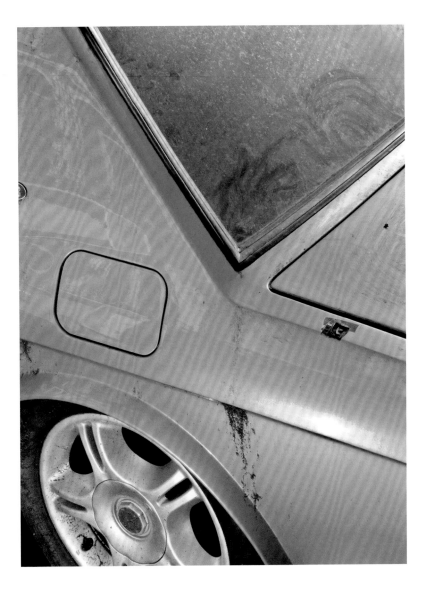

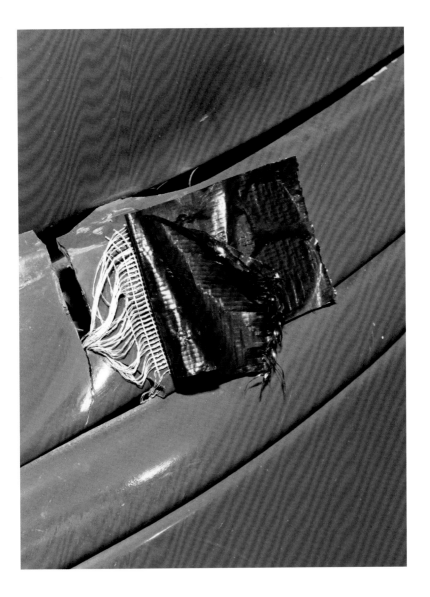

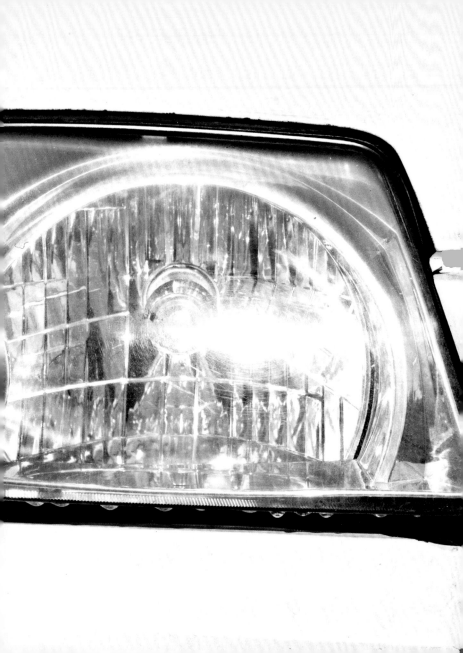

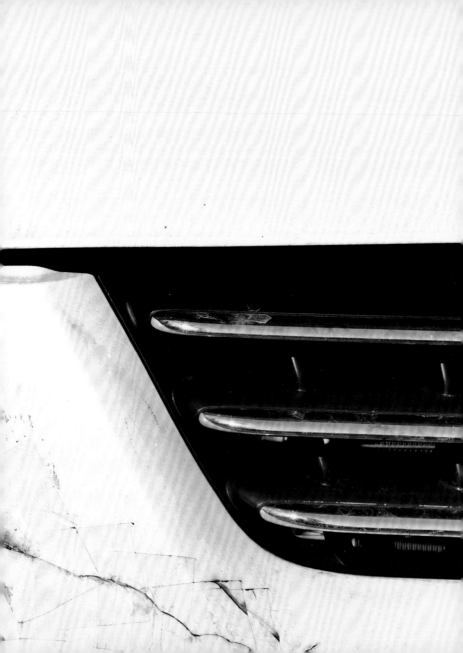

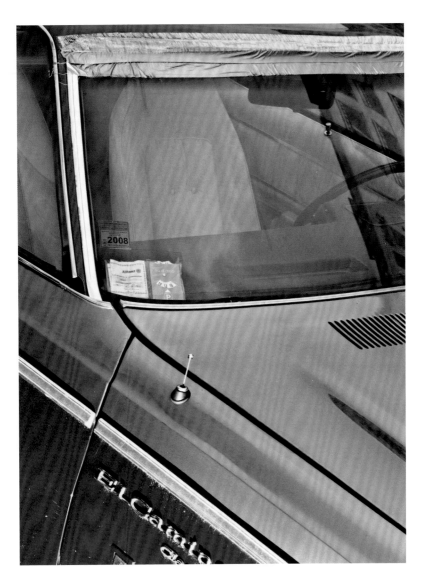

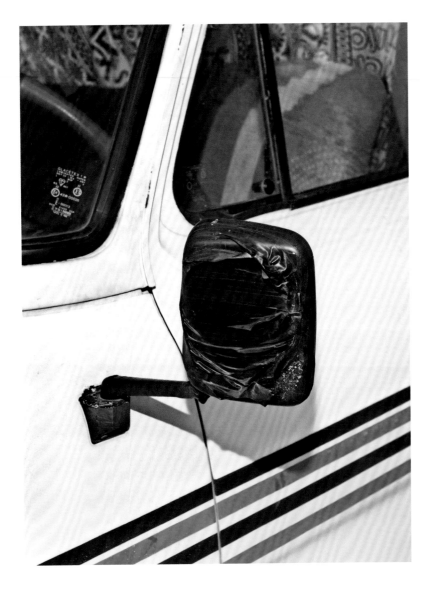

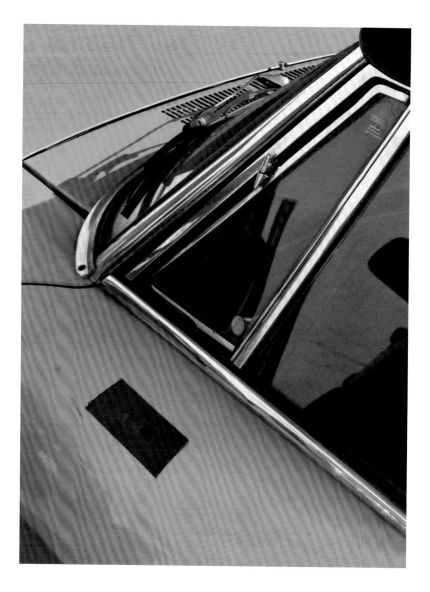

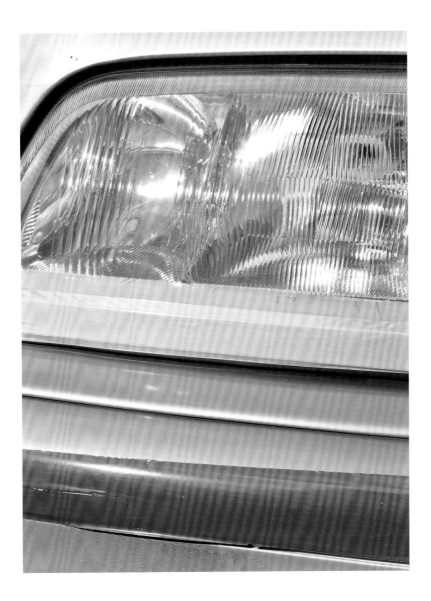

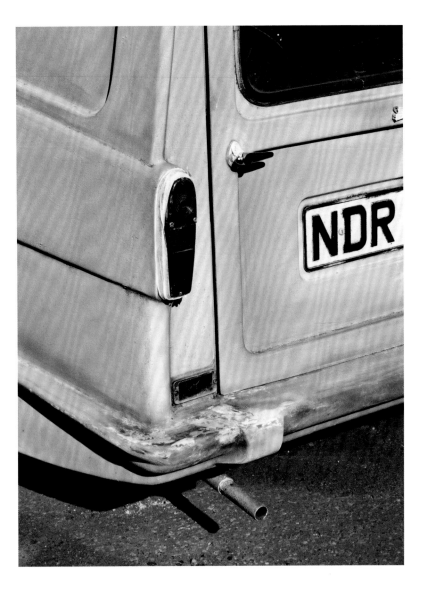

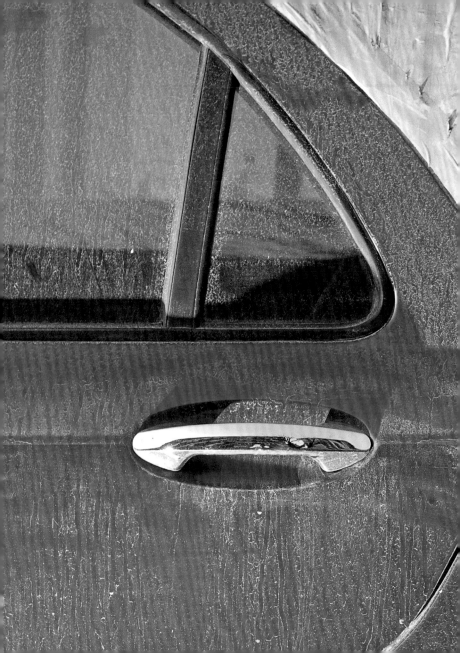

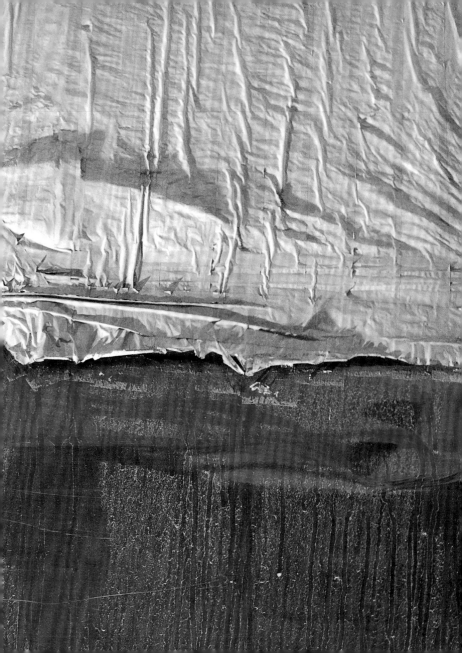

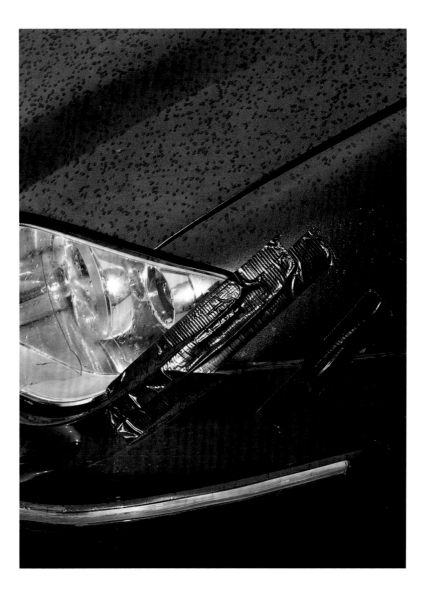

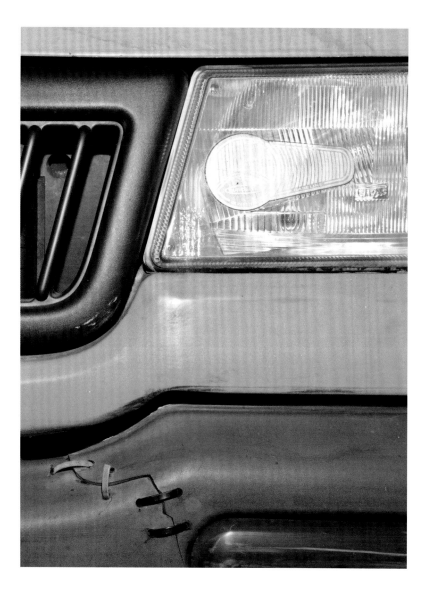

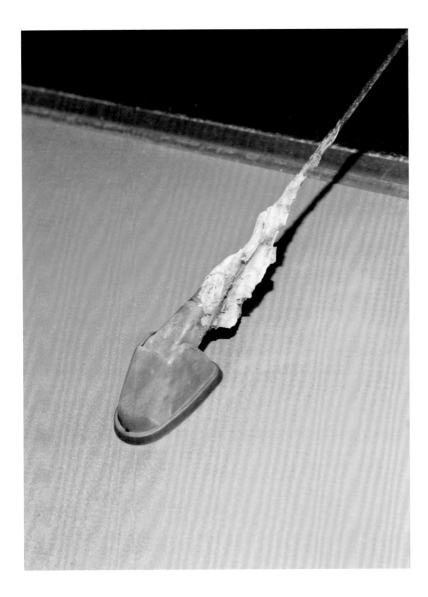

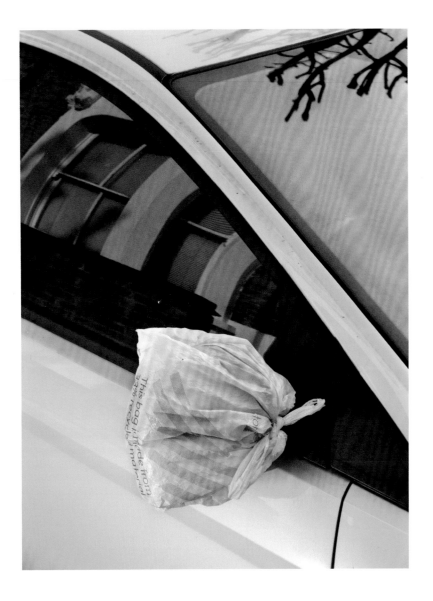

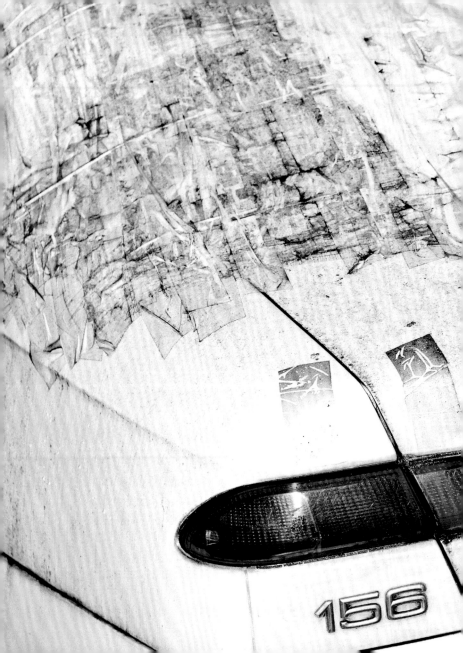

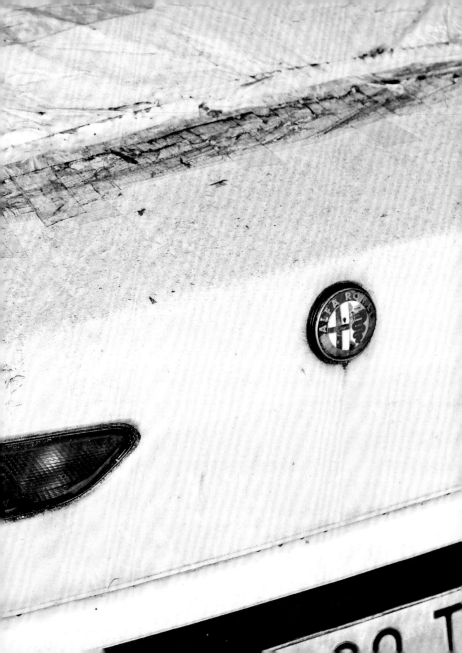

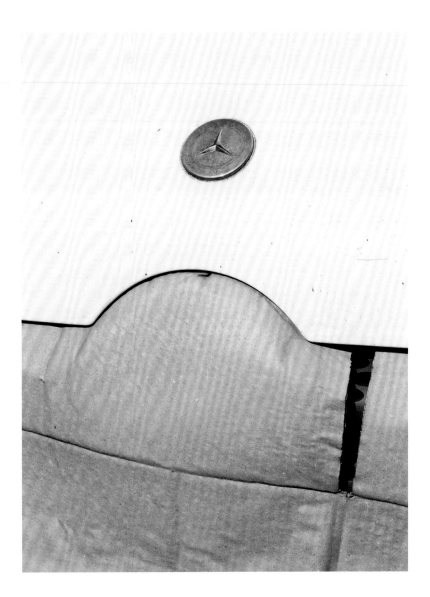

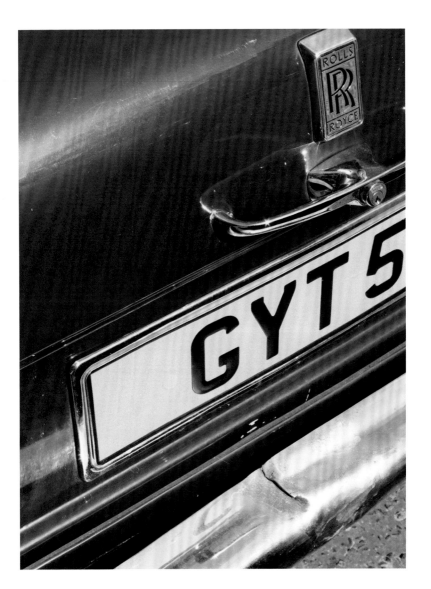

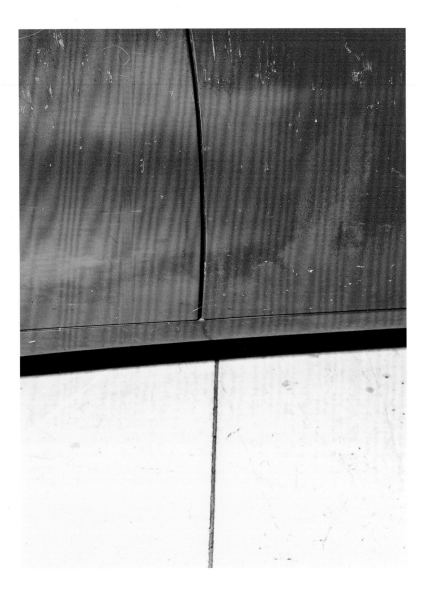

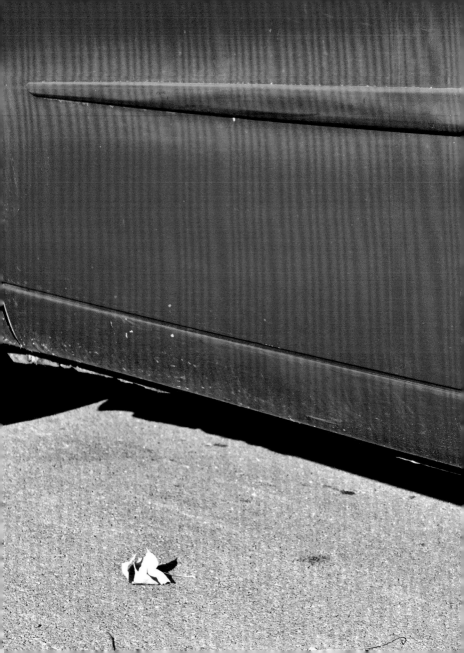

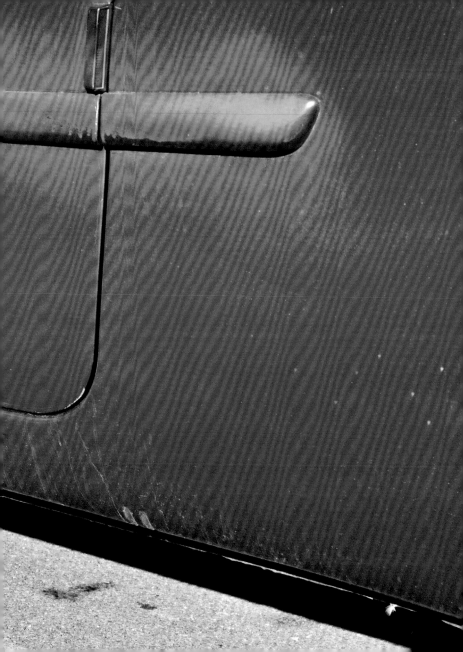

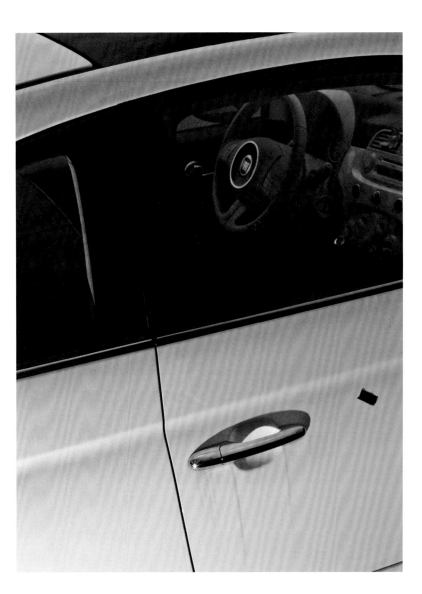

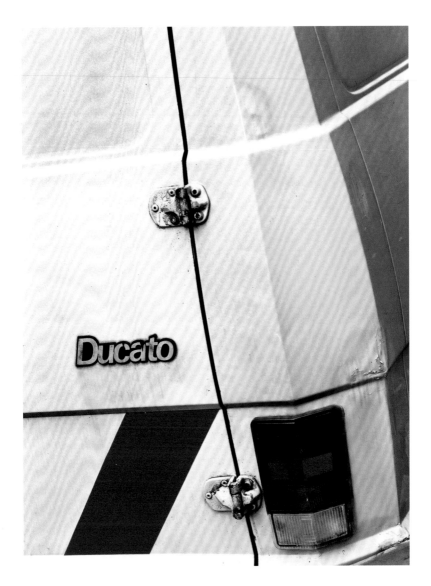

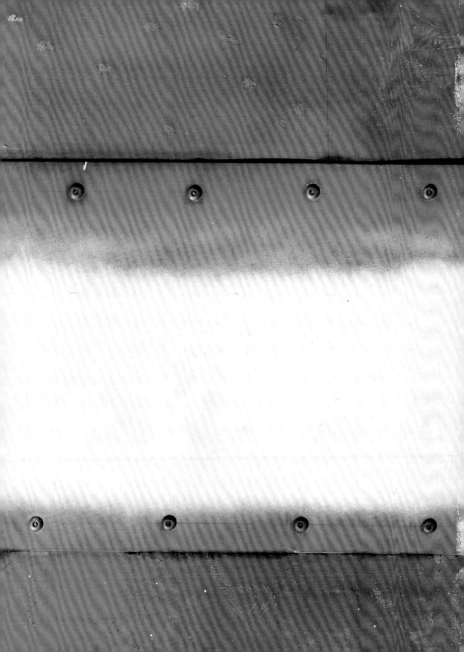

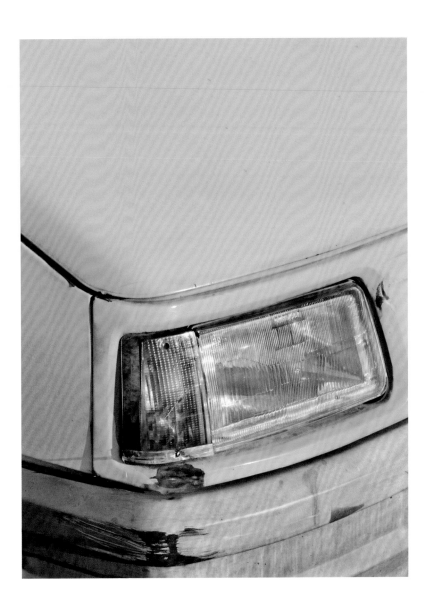

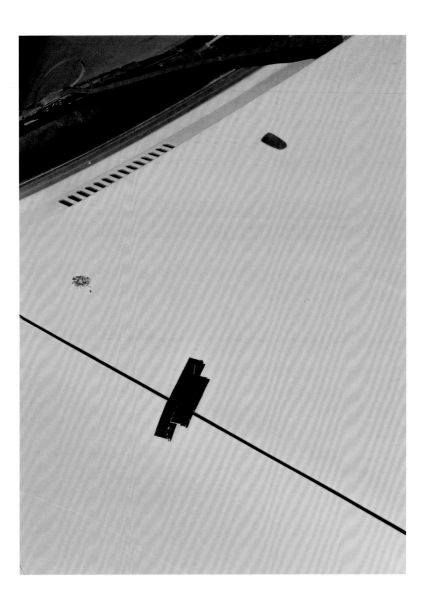

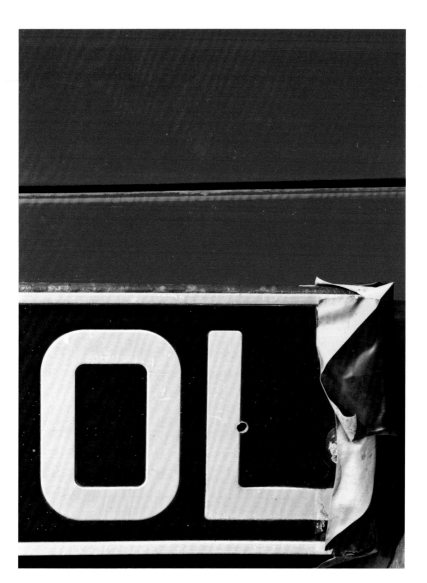

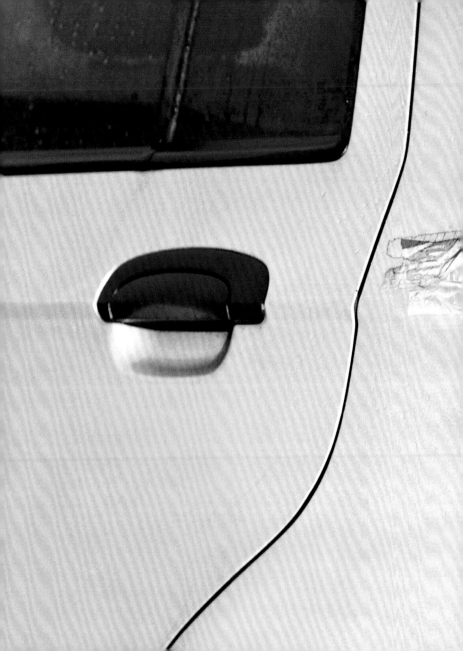

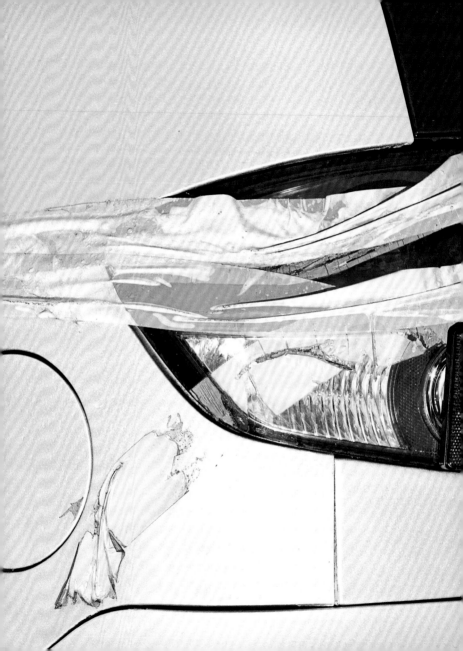

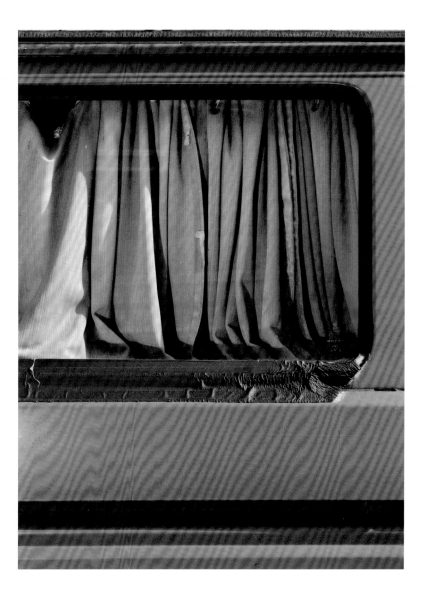

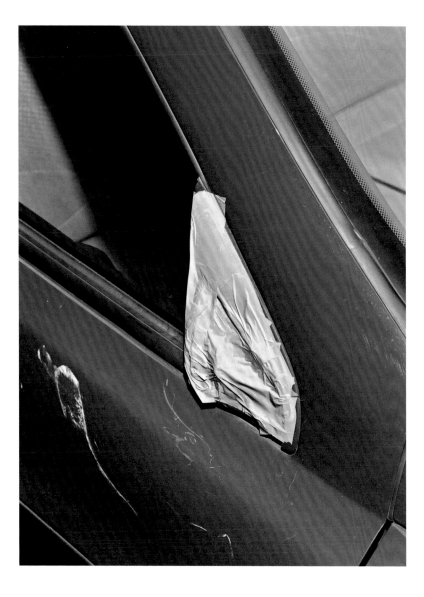

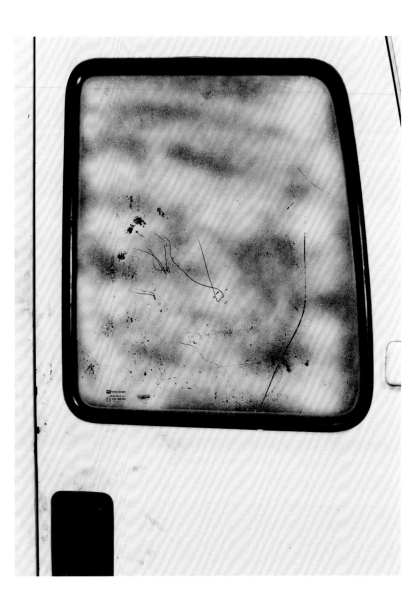

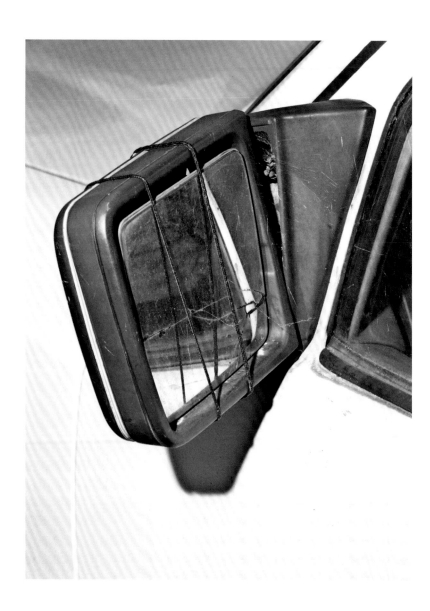

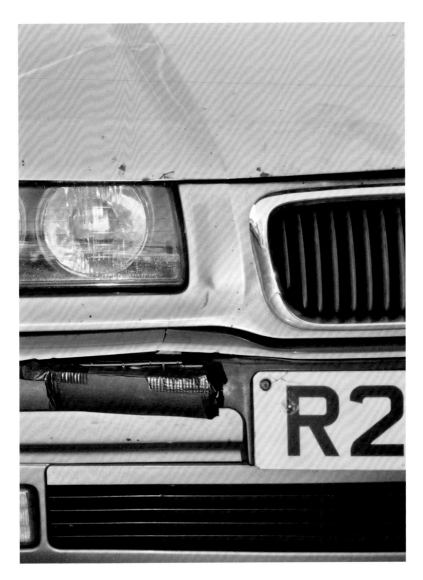

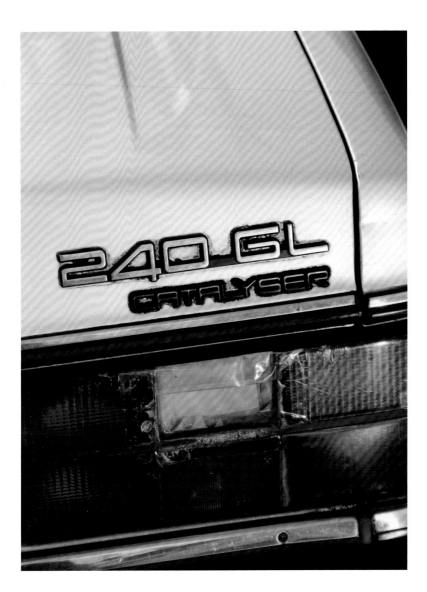

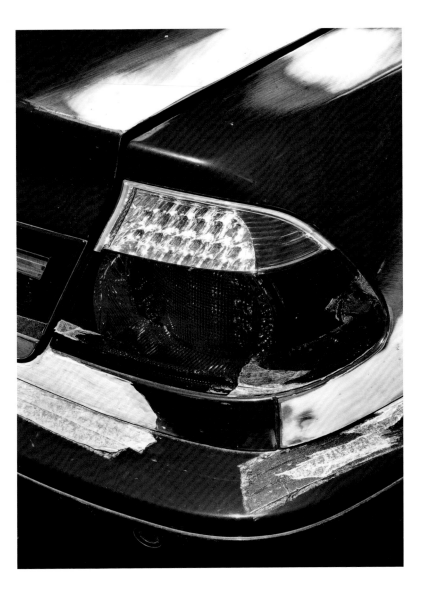

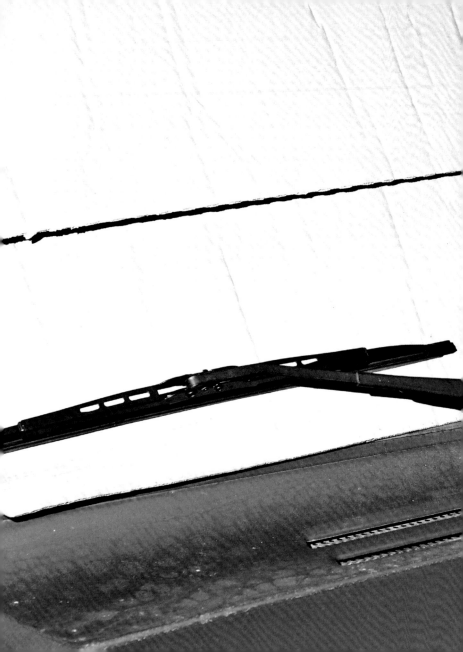

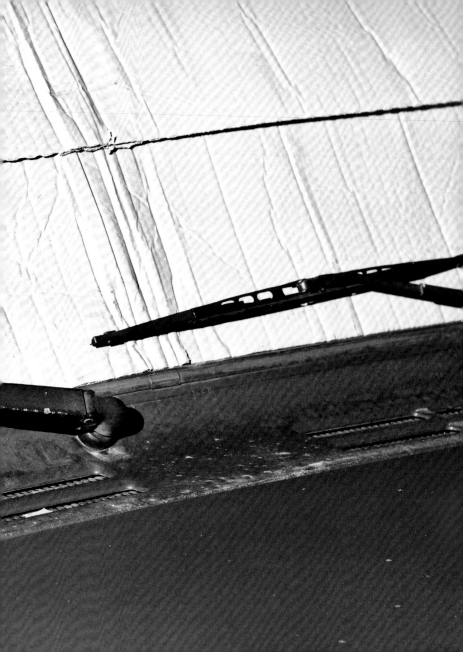

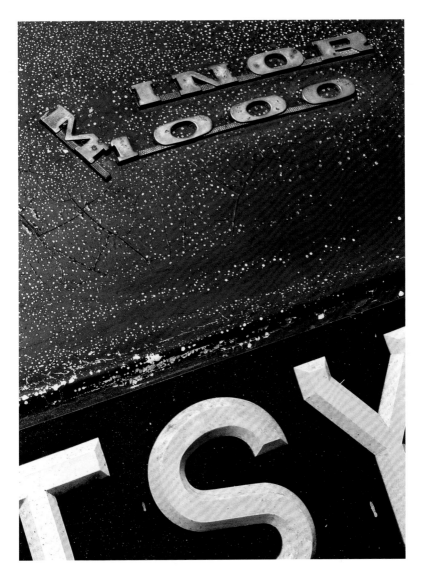